# The Art of *Calligraphy*

Projects and artwork by Raymond Duckworth Dip.Arch
Written by Susannah Bradley

## TOP THAT!™

Published by Top That! Publishing plc
27101 Breakers Cove, Valencia, CA 91355
www.topthatpublishing.com
Copyright © 2003 Top That! Publishing plc
Top That! Kids is a trademark of Top That! Publishing plc
All rights reserved
8 9 7
Printed and bound in China

# Contents

**4** Introduction

**6** Tools for the Job

**8** Getting Started

**10** Pen Practice

**12** Constructing Letters

**14** Spacing

**16** Brush Lettering

**18** Gilding

**20** Using Color

**22** Saying it with a Flourish

**24** Layout Techniques

**26** Illumination

**28** Borders

**30** Reed Pens & Quills

**32**   Alphabets

**34**   Roman & Rustica

**36**   Uncials

**38**   Gothic

**40**   Italic

**42**   Copperplate

**44**   *Project One*
Menu and Place Card

**48**   *Project Two*
Bookmark

**52**   *Project Three*
Labels for Herb Jars

**56**   *Project Four*
Christening Invitation

**60**   What Next?

**62**   Glossary

# *Introduction*

In today's technological age, with all its computerized fonts, it would be easy to regard calligraphy as an outmoded art form.

However, this captivating craft continues to fascinate generation after generation. The appeal of calligraphy may lie in the sense of satisfaction gained from creating something beautiful, or from the versatility of the skills which can be applied to glass, china, wood, cloth, and even on walls, as well as the conventional use of lettering on paper and card.

This is a beginner's guide, for those who know nothing about calligraphy and have never tried to produce this "beautiful writing" (the literal meaning of the word "calligraphy".)

Many cultures have a rich history of writing techniques, but in this book we have worked with only the European styles.

You'll learn the fascinating history behind the different scripts, and follow the old traditions as you try them out for yourself. You will be encouraged to adapt, and create new styles to suit yourself, whether you are right- or left-handed.

1887 ~ Rupert Brooke ~ 1915

He who has found our hid securi
Assured in the dark tides of the
And heard our word, 'Who i
We have found safety with all
The winds, and morning,
The deep night, and birds sing
And sleep, and freedom, and
We have built a house that is
We have gained a peace
War knows no power. Safe
Secretly armed agains
Safe though all safety's lo
And if these poor limb

# Tools for the Job

**As with any skilled hobby or craft, good tools are essential for creating quality projects.**

The implements included in this set provide an excellent starting point and introduction to calligraphy but to get the most out of this art form you may wish to collate a more complete set of tools. The following items will certainly be of use as you find your feet:

*Pen nibs and reservoir*

*Brushes*

*Colored card and papers*

- Dip pen holders, nibs, and reservoirs (these are tiny metal pieces which clip behind the nib of a dip pen to hold ink)

- Pencils – choose HB to 2B

- Calligraphy marker pens in different sizes

- Watercolor and gouache paints

- Brushes – fine sable for filling in color between lines, cheap ones for loading paint on to pen nibs, and chisel-edged ones for drawing letter shapes

- Calligraphy inks

- A pad of layout or tracing paper

- Good cartridge paper for your finished work

- Ruler

- Eraser

- Glue for applying metallic foil and gold leaf

- A jar of clean water for cleaning dip pens and brushes

- You will also need some rags for wiping your pen nibs. Use paper towel for mopping up spills, but not for wiping brushes, as shreds of paper can clog your nibs and brushes

- You may also like to buy a calligraphy fountain pen (these sometimes come in sets with a range of nibs and cartridges) for either right- or left-handers

*Watercolor paints*

# Getting Started

**You can get the feel of what it's like to write in a calligraphic style before you buy anything especially for the job.**

**1** Prepare a piece of paper to work on by drawing a pencil line across it on which your letters will sit. This is called a baseline.

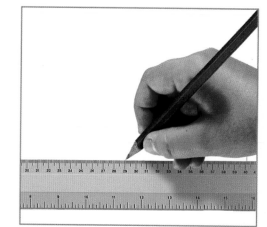

**2** Now bind two well-sharpened pencils together with tape so that their points are level. As you write with them, keep them at a rigid angle to the paper, so that all the marks you make in one direction have a space between them, while others merge into one. The ideal angle is about 40°.

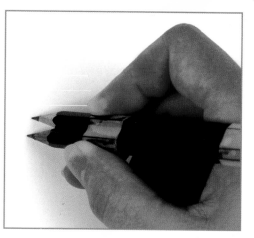

**3** In comparison to the freedom of everyday writing this may seem strange, but you'll recognize the shapes made by your double pencil as a version of those you see all around you—on book jackets, posters and even carved into monuments.

**4** You'll find that your letters need to be a certain size to look correct. Smaller ones look incorrect because the thickness of the pencils keeps the two points a certain distance apart. Try shading them in with your pencil to see how solid they can look.

**5** Draw some diagonal lines or try experimenting with writing at different angles.

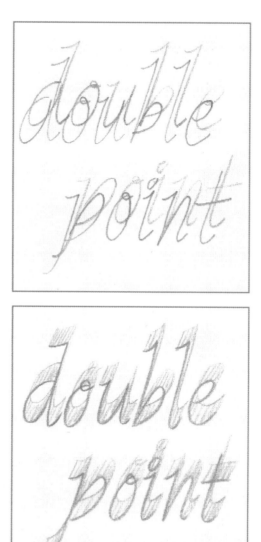

# Pen Practice

**Calligraphy is a skilled craft that will require time and patience to perfect. Follow these basic guidelines though and soon you will be able to master complicated projects.**

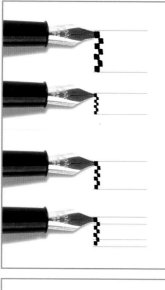

*Ruling the paper*—Just as the double pencils determined the size of your letters, so will the thickness of a nib. The general rule is to draw the body of a lower-case letter about five times the nib width; exact details for each lettering style are given with the complete alphabets. This distance is called the x-height.

Draw a pencil line across the paper and make seven pen strokes in a checkered pattern up from there (known as a ladder.) Draw the next line at this point, parallel to the first one.

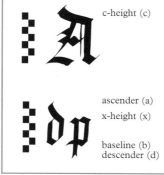

c-height (c)

ascender (a)
x-height (x)

baseline (b)
descender (d)

Capital letters need to be taller than this and those lower-case letters with ascenders or descenders —like b,d, j, and so on—need more nib widths still. At first, allow twice the width of the writing lines between each pair of lines to ensure that descenders from the first line do not get in the way of ascenders below.

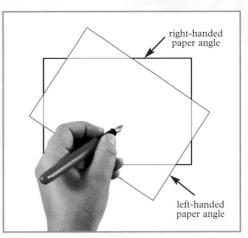

right-handed paper angle

left-handed paper angle

Although tedious, it is necessary to draw up guide lines before you start to draw your letters. If you work on layout paper you can rule your lines on one sheet and then work on another, fixed on top; you will be able to see through to the guide lines, which you can then use again.

*Assembling a dip pen—*
Choose one of the wider nibs to begin with and push it firmly into the pen holder. Push the reservoir into place behind the nib.

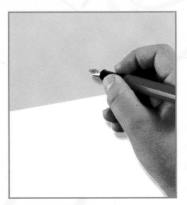

*Paper angle for left-handed people—*
Right-handed people work with the paper placed straight before them, but those who are left-handed must slant the paper at an angle rather than have it straight in front of them. The angle may vary so choose one that suits you but ensure that the light remains on your right.

Some left-handed people write with their writing arm at the top of the work, their hand curling round to hold the pen. You can't do this with calligraphy. Instead, the hand should be under the work, with the left elbow close to the body.

*Keeping your work clean—*
Fix a piece of paper over your work sheet to rest your hand on as you work, and reposition it each time you start a new line. Use a guard sheet even when practicing, to become used to it.

# Constructing Letters

**Foundation hand is a good first style to practice since it is clear and open.**

## Alphabet construction

**Pen angle:** 30°

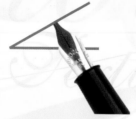

*For the letter z turn the pen so that it makes a thick line on the diagonal downward stroke.*

### C-height

c-height (c)

baseline (b)

*4.5 pen widths body height, with an extra 4.5 pen widths for both ascenders and descenders*

Initially, try thinking of your letter as fitting into a series of circles, squares, and rectangles. Eventually this will be second nature to you.

*Narrow letters*
Divide the circle in half and you get the width of the narrow letters.

*Round letters*
Round letters are based on a circle.

*Rectangular letters*
Rectangular letters fit into the rectangle shown in red on top of the circle.

*Wide letters*
Wide letters go outside the full circle. M has splayed verticals, meaning that the letter is wider at the bottom than it is at the top. W is the widest letter of all as it looks like two v shapes.

*Follow the direction and sequence of the arrows to create perfect Foundation hand.*

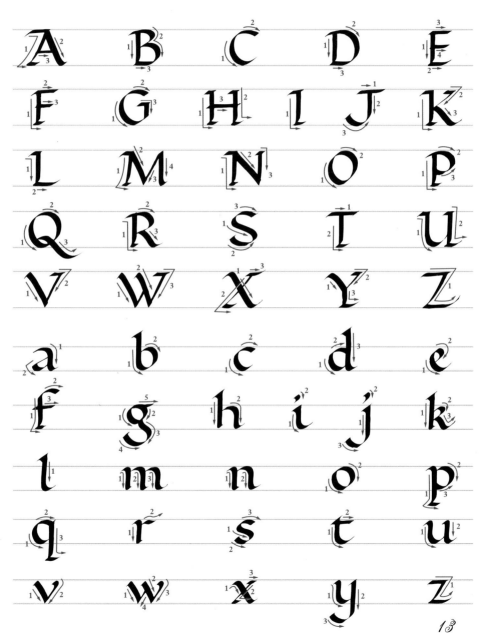

# Spacing

**Space between letters matters—not enough, and the words looks cramped, too much and the words appear to fall apart. Judging the spacing is a skill which becomes easier the more you work at it.**

For the correct spacing between words leave the width of a lower case o. This size of gap will create enough space between letters without causing a pattern of blank lines to appear to run jaggedly though a piece of work which is several lines long.

Incorrectly spaced work is clearly evident but the process will become second nature to you with each project you complete.

As a general rule, numbers are usually the same size as capitals, as are exclamation points and question marks.

Spacing is Important Because

*Here's a tip: Leave more space between two letters which have straight strokes next to each other than you do between curved letters.*

Looking forward to the spring
One puts up with anything.
On this February day
Though the winds leap down the street
Wintry scourgings seem but play,
And these later shafts of sleet
-Sharper pointed than the first-
And these later snows -the worst-
Are as a half-transparent blind
Riddled by rays from sun behind.

Shadows of the October pine
Reach into this room of mine :
On the pine there swings a bird ;
He is shadowed with the tree.
Mutely perched he bills no word ;
Blank as I am even is he.
For those happy suns are past,
Fore-discerned in winter last.
When went by their pleasure, then ?
I, alas, perceived not when.

Before and after Summer
Thomas Hardy

# Brush Lettering

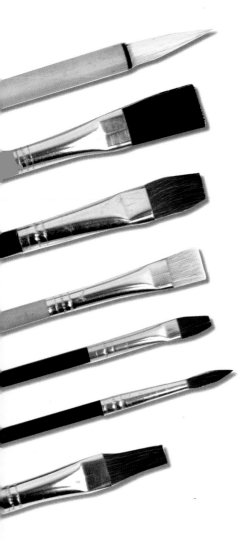

**While pen and ink are essential in calligraphy, your basic grounding in this art form would not be complete without a mention of brushes and brush lettering.**

Not only are brushes useful for painting the delicate decorations of borders and illuminations, they can also create striking lettering that is far freer than that created by using a pen nib.

Using either ink or paint on broad, flat, round- or square-tipped brushes you can paint a variety of effects. Working on a larger scale you can make bold statements and experiment by layering colors and wet paints.

Chinese bamboo brushes
come to a fine point and
make a completely
different stroke to that
of a watercolor brush.
Try using the one in this
set to recreate eastern
inspired pieces.

When constructing
individual letters it is
worth remembering the
stroke sequences as
outlined in the various
alphabets. This will help
maintain the look of
calligraphy while the
softness of the brush
will add interesting, and
often beautiful, touches
of irregularity.

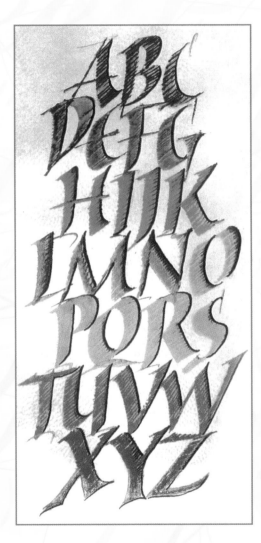

# Gilding

**Ornate manuscripts owe much of their beauty not only to the fine paintwork but also to the stunning gilding and raised gold so meticulously applied by scribes. Although seemingly tricky to begin with, the process of gilding is worth mastering and will take your projects onto a new level.**

Metallic foil is included in this pack to get you started in using gilding to enhance your work. For future projects you may wish to buy gold leaf, which can be bought easily from most good craft shops; the application of either is very similar and both can be used in the projects featured later.

Traditionally, gum ammoniac (a gum resin) is used in gilding, but some methods mention gesso, a mixture of plaster and size, gum arabic, or alternatively you will find that some glues will give equally pleasing results for gilding. Ask at your local craft store for more advice on brands and new products.

**1** To begin any gilding work, first define the area lightly in pencil.

**2** Within this outline you need to apply some glue, gesso, or gum arabic, making sure not to leave any gaps since these will show in your finished work.Leave the glue to dry until tacky.

**3** Meanwhile, use sharp scissors to cut an appropriate piece of gold foil or leaf, (gold leaf comes with backing tissue that must be kept face up on the back of the gold.)

**4** Place it shiny-gold side down onto the area to be gilded and dab it gently into place until your design is securely covered with the gold.

**5** When you're satisfied with the result gently peel away the foil. The gold should come away from the foil and stick to your design, leaving you holding a clear film. If using gold leaf, carefully remove the backing tissue. If any of the leaf comes off the area to be gilded, carefully press some more into it.

**6** Leave the gold leaf for 24 hours to dry completely before you move on to the next stage, which is to remove the excess. Do this by stroking around the edges with cotton wool or a soft brush. To achieve a glossy finished burnish use a burnisher. These are available from craft stores.

# *Using Color*

Calligraphy ink is available in a range of colors and can be mixed to make others. Inks can then be applied to the reservoir of a dip pen using the mixing brush.

If you are using fountain pens, it is best to keep one pen for each color, or you will be forever washing them through before fitting an alternative cartridge. This can be expensive, so you may wish to use color only with dip pens.

Wash dip pens carefully as you go, and dry them on a soft rag.

Experiment by changing color in mid-letter, or try picking out important words in color in a passage of black text.

Painting inside an outlined letter is also distinctive. Use a fine brush and be careful not to wet the drawn letters to avoid getting lines running into the color. To avoid this, draw letters with a sharp pencil and then define the outline with a fine pen, or brush, after the paint has dried. Keep a waterproof fine-drawing pen for this purpose.

Another way to introduce color into your work is with a painted background. Before you begin any calligraphy, however, make sure the paint is dry.

Gouache paint, which is available in tubes, may be used in the reservoir of a dip pen when mixed with water. Mix plenty before you begin, to be sure of keeping the same consistency and color throughout a piece of work. Practice with each color—they react differently—and rinse and dry your pen often as you go along. Do not use acrylic paint in your pens, as it will ruin them.

# Saying it with a Flourish

**There are few rules, or restrictions, with flourishes so have fun creating them.**

You can put flourishes wherever you like—sometimes they rise dramatically above the lettering, from an ascender; at other times they will add a tail, jauntily underlining a word or letter.

However, carefully consider how flourishes can enhance your work —innumerable examples can be found in books, museums, and carvings.

You should consider them as free-flowing extensions to your lettering and as such they should look natural within the body of text.

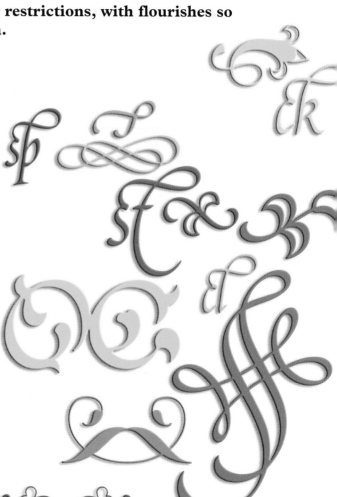

# *Monograms*

**As a personal, or finishing touch, monograms can be the perfect vehicle for practicing flourishes.**

Try designing a monogram with one, or more, of your initials.

This may, or may not, include a flourish. Some combinations are fraught with problems before you begin—IV can look like an arrow or a badly drawn N, while initials which spell out a word need twisting to conceal the word.

Work in rough and with different pen thicknesses until you find a solution.

# Layout Techniques

**The position of text on the finished page is a very important part of calligraphy. The layout will give shape and importance to your work.**

The size of your pen and the size of paper you have must work together. It is no good using a large nib if your longest line will not fit onto the page, so write out that line first to make sure it does fit. Your writing may be placed straight, diagonally, or curved, but in each case be prepared to write it out several times.

A useful tip is to cut out and place your lines onto a layout sheet the same size as your intended finished version. This way you can experiment with as many versions as you like before settling on the best one.

Myself when young did
eagerly frequent
Doctor and Saint, and heard
great Argument
About it and about: but
evermore
Came out by the same Door
as in I went.

From the Rubaíyat
of
Omar Khayyam
The Persian poet and Astronomer
c 1100

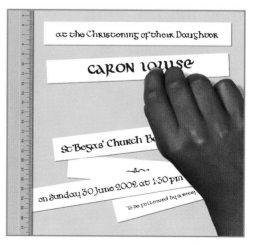

at the Christening of their Daughter

CARON LOUISE

St Bega's Church B

on Sunday 30 June 2002 at 1.30 pm

To be followed by a recep

# Curved Lines

Sometimes you will want to write in circles or in wavy lines. This really has to be drawn out first in pencil with a curved baseline to ensure good positioning. If using colored lettering, erase the pencil as you go along, or it will show through the paint.

Move the paper a small amount each time you write, so that you are at the correct angle to the writing line for each letter. If you don't do this, your lettering may become distorted, even though you are keeping within the lines.

Alternatively, write out a straight line of lettering, cut it out, snipping halfway between each letter. Then curve the line as needed and use it as a guide for the final piece.

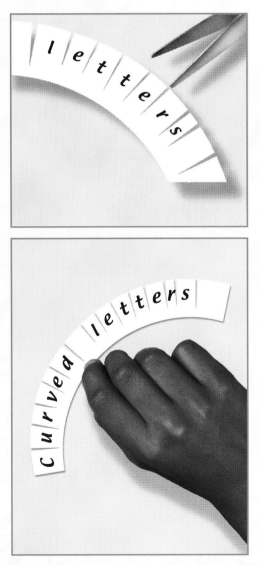

# Illumination

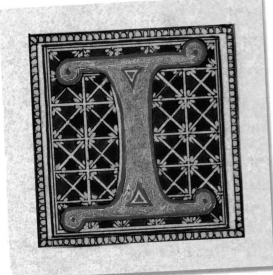

**The glorious decoration of ancient manuscripts is known as illumination.**

In the days between the spread of Christianity in the fifth century AD and the increased availability of printed books in the sixteenth century, scribes labored to produce works for the glorification of God and the education of man. Religious texts were decorated with the most intricate, delicate and beautiful designs as an act of worship.

Monks and scribes worked on vellum, which is a type of treated calfskin. Although still available today for dedicated calligraphers to use, beginners should work on good, smooth paper. Likewise, the use of gold for beginners may be kept to gold pens, paint, or metallic foil while you are learning. Later, you can try using gold leaf or powder.

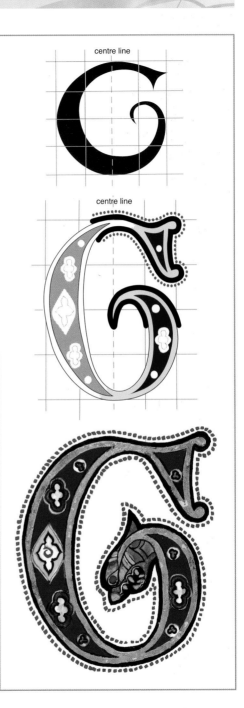

**1** While you are a beginner, concentrate on the drawing and design of the large, complicated capitals that begin a passage of text in an illuminated manuscript; these are known as illuminated versals. Later on you may decide to have smaller illuminated versals dotted around in the text as well.

**2** When designing your own, use any letter form you like. Try enclosing the letter in a box and adding a patterned background; an all-over geometric background is known as "diapering."

**3** You could add a motif that climbs over the letter, for example animals, creeping vines or flowers. Alternatively, fill the letter itself with designs, as shown here.

# ❧ Borders

**Illuminated manuscripts often had decorative borders as well as beautiful versals.**

Borders have been used to beautify and add importance to many passages of text, throughout the centuries.

Space is important on a page, so make sure you know the area needed for the main body of text. Write it out carefully on another sheet and transfer its measurements to the paper you will use for the finished work.

Unless incorporating small pictures that reflect the subject matter of your text, the four basic elements to a border are: dots, horizontal, vertical, and diagonal lines. Experiment with different combinations of these four elements and mix techniques and materials to create striking borders.

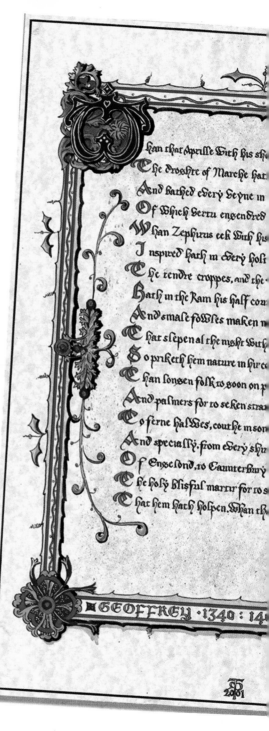

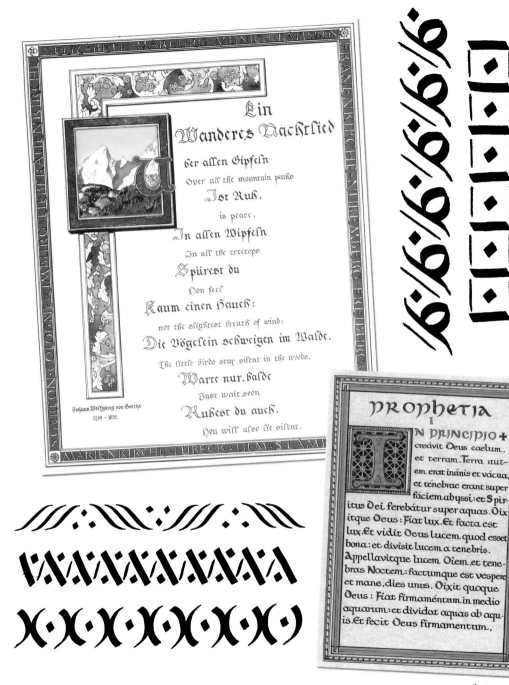

Ein
Wanderes Nachtlied

über allen Gipfeln
Over all the mountain peaks

Ist Ruh.
is peace,

In allen Wipfeln
In all the treetops

Spürest du
You feel

Kaum einen Hauch:
nor the slightest breath of wind;

Die Vögelein schweigen im Walde.
The little birds stay silent in the woods.

Warte nur, balde
Just wait, soon

Ruhest du auch.
You will also lie silent.

Johann Wolfgang von Goethe
1749 – 1832

## PROPHETIA

### 1

IN PRINCIPIO ✦ creávit Deus caelum, et terram. Terra autem erat inánis et vácua, et ténebrae erant super fáciem abyssi: et Spíritus Dei ferebátur super aquas. Dixitque Deus: Fiat lux. Et facta est lux. Et vidit Deus lucem quod esset bona: et divisit lucem a tenebris. Appellavítque lucem Diem, et tenebras Noctem: factúmque est vespere et mane, dies unus. Dixit quoque Deus: Fiat firmaméntum in medio aquárum: et dividat aquas ab aquis. Et fecit Deus firmamentum.

29

# Reed Pens & Quills

**Reed pens are a traditional utensil in calligraphy, the use of which dates back to the Egyptians, who used them on papyrus. In comparison to other pens you may find the reed pen difficult to use but often the bold results make it worth persevering with.**

Quills are made from the five long tail feathers of geese, but before they are made into pens they must be cured. To do this, cut the tip off the quill, soak it in water for several hours and then plunge it into heated sand, leaving it there for several seconds for it to harden.

You may need to try this out on several quills before you get it right; a simpler solution would be to buy your quills already prepared. Ask at your local art store, or search the internet to locate suppliers.

# *Making your own reed pen*

**A reed pen can be conveniently made from a twig.**

**1** Using a craft knife, and cutting away from you, make a diagonal slant at one end. This becomes the back of the nib.

**2** Scoop out the soft part inside with the point of your knife.

**3** Trim the nib to the size you want. Slice downwards into the nib, as shown. Your reed pen is now ready to use.

# Alphabets

**In order to become familiar with all the alphabets in this book, make copies of them, enlarge to a size that you find comfortable to work with and use them as a guide.**

Place layout paper over the copies and, using a pencil, match the thickness of the letters by drawing over them. By doing this, you will get used to the letters and eventually gain the confidence needed to draw them freehand.

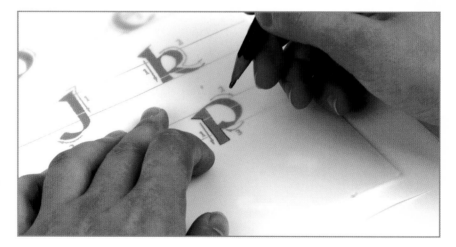

This method is very good at helping you to judge spacing between letters.

Whan that Aprille With his shoures sote
The droghte of Marche hath perced to the rote,
And bathed every veyne in swich licour,
Of Which vertu engendred is the flour;
Whan Zephirus eek With his swete breeth
Inspired hath in every holt and heeth
The tendre croppes, and the yonge sonne
Hath in the Ram his half cours y-ronne,
And smale fowles maken melodye,
That slepen al the night With open yë,
So priketh hem nature in hir corages :
Than longen folk to goon on pilgrimages
And palmers for to seken straunge strondes
To ferne halwes, couthe in sondry londes;
And specially, from every shires ende
Of Engelond, to Caunterbury they Wende,
The holy blisful martir for to seke,
That hem hath holpen, Whan that they Were seke....

THE CANTERBURY TALES · C · 1387 ·

✠ GEOFFREY · 1340 : 1400 : CHAUCER ✠

# Roman & Rustica

**The Roman style of lettering is the bedrock of all our calligraphy styles.**

## Alphabet construction

**Pen angle:** 30°

*Roman letters can be written with a broad pen, held at an angle of 30°, for most strokes.*

## C-height

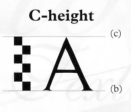

(c)

(b)

Although developed from Greek lettering, the Roman alphabet has superseded the original Greek form in importance because of the greater similarities between Roman and modern alphabets. All other writing styles used in western calligraphy are derived, or developed, from this style.

Roman letters may have serifs or may not. In stone carving, the serif was carved first in order to stop the chisel as it gouged out straight lines.

## Rustica Alphabet

Rustica is a style of writing which was used in ancient times for public notices since it could be easily drawn in a free manner on walls. If you later experiment with a homemade reed pen, try out the Rustica alphabet with it.

# Roman

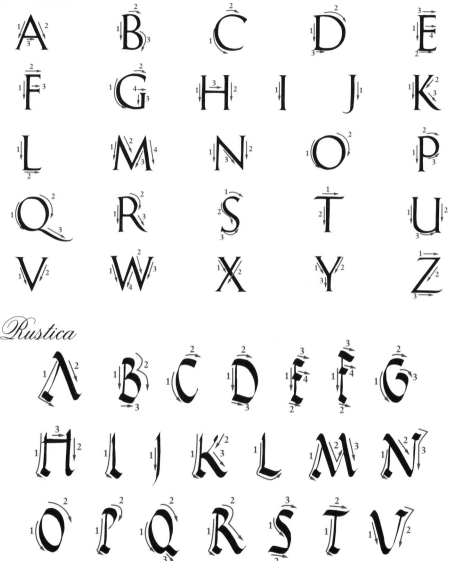

# Rustica

# *Uncials*

**The Uncial alphabet was designed by monks to be used when writing long texts.**

## Alphabet construction

---

**Pen angle:** 15°

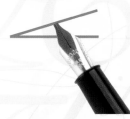

*Uncial letters can be written with a broad pen, held at an angle of 15° for most strokes.*

**C-height**

**X-height**

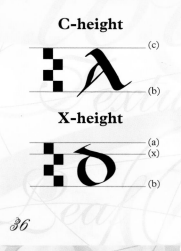

The squat appearance of uncials enabled scribes to fit a lot of lettering on each page, but the open spaces within the letters prevented each page from seeming cramped.

The capital letter is a comparatively modern invention so you may find some alphabets consist of only lower-case letters. If you need a capital you may use one from the Uncial alphabet, and adapt it to suit your needs, ensuring that the capital is of an appropriate size.

*Uncial alphabets can vary in style slightly but follow the direction and sequence of these arrows to create a basic form of Uncial.*

# *Gothic*

**There are several styles of Gothic alphabet that vary only slightly from one to another.**

## Alphabet construction

**Pen angle:** 40°

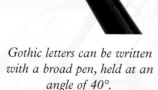

*Gothic letters can be written with a broad pen, held at an angle of 40°.*

**C-height**

**X-height**

Gothic, Sharpened Gothic, Bastarda, Black-letter, Fractur, Textura, and Rotunda are all varieties of the Gothic alphabet. They were deliberately developed in a complicated way to deter forgers. For this reason they can be difficult to read, but are satisfying to draw.

As beginners like to build up a varied portfolio from the start, the example given here is one of the elaborate styles. The ascenders and descenders are short and the spacing is close, giving a passage of text a density unlike other, more open, alphabets.

*Follow the direction and sequence of the arrows to create this version of Gothic script or seek out your own examples.*

# *Italic*

**The Italic hand was designed as a reaction in Italy to the excessive complexity of the Gothic scripts.**

## Alphabet construction

**Pen angle:** 45°

Its elegant style was perfect for writing when speed and style were important. It slopes, has long ascenders and descenders, and is clear to read.

The most difficult thing to master is the constant 45° angle of the downward strokes.

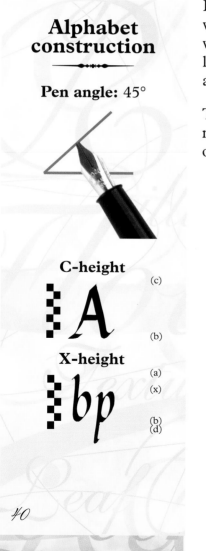

**C-height**

(c)

A

(b)

**X-height**

(a)

bp

(x)

(b)
(d)

*Remember to maintain the 45° angle as you follow the direction of the arrows.*

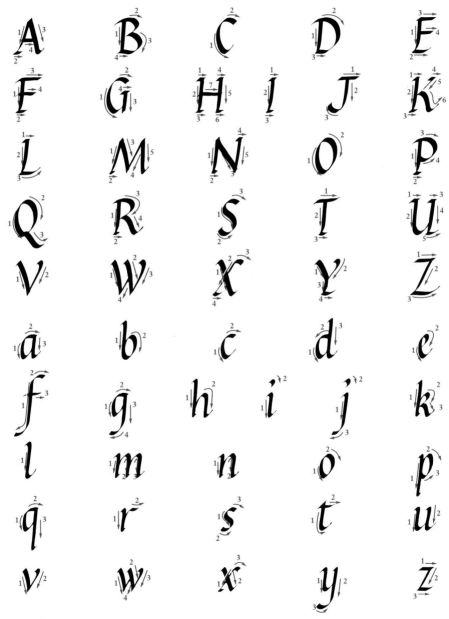

# Copperplate

## Alphabet construction

**Pen angle: 54°**

**C-height**

(c)

(b)

**This hand is different from all the others in that it resembles normal handwriting, uses a thin nib and doesn't require a fixed pen angle.**

Taught in schools well into the twentieth century, copperplate is hated by many older people for that reason, as they remember the struggle their childish hands had, the blots, and the scoldings they received for untidy work.

Yet Copperplate writing, done well, is a delight to the eye and easy to read, and in the context of an art form rather than the schoolroom it can be a pleasure to do. It looks wonderful on formal invitations, even when only the name of the guest is handwritten onto a preprinted card.

*Open and flowing Copperplate is a great alternative to other alphabets.*

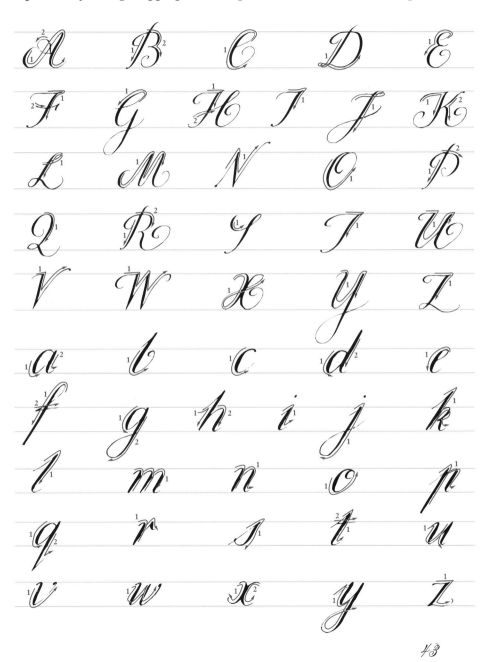

# MENU

Avocado Mousse

◆

Sea Bass with Sorrel Hollandaise

Potatoes All-i-oli

Carrot Cosimber

◆

Pear & Green Peppercorn Sorbet

Biscotti di Mandorle

Samantha

# Project One
## Menu and Place Card

### YOU WILL NEED

Artist's watercolors and/or gouache paint

Calligraphy ink

Craft knife and cutting board

Silver foil from pack

A metal ruler

Paper—artist, sketch, and tracing

Paint brushes

Pencils—HB, conté carbon, and an eraser

Pen nibs—including a mapping pen and fine nib

Purified water (for washing pen nibs and brushes)

Glue, gum arabic, or gesso

Waterproof black ink or waterproof French sepia

**A special meal for a special occasion deserves to be made even more memorable with a handwritten menu and individual place cards.**

Why not theme your design to reflect the dishes to be served, as the example shown here does?

If you prefer to keep your design simple and let the dishes speak for themselves, then a plainer, abstract border will be enough to add just a little touch of class to the event.

**1** Select the paper size for the menu and place cards and choose a script.

Menu cards are usually designed on either 6³/₄ in. x 8¹/₂ in. paper or 8¹/₂ in. x 11 in., the size of the place cards should complement the menu. Work in rough first.

**2** The menu must be set out on tracing paper using a point system for each letter. Choose the longest line, center upon the card and adjust other lines to fall in place. Remember to leave room for the fish at the bottom of the menu and space for margins and borders.

**3** Once you are happy with the positioning of the words, border and fish, use a tracing to position it upon the final piece and lightly go over these guide lines with another pencil.

**4** Start working over the lines with a fine mapping nib. Waterproof ink should be used on areas that will come into contact with color. When dry, erase any pencil lines.

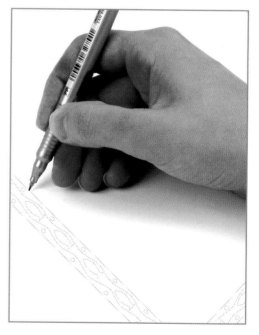

**5** Once the ink has dried on the fish use the silver foil as you would the gold, applying it to tacky glue and then gently peeling off. Finalize any remaining areas of the fish with calligraphy, or waterproof, ink.

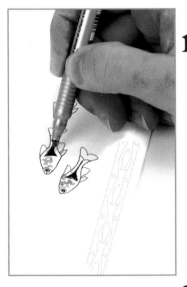

**6** Once gilding has been completed, the rest of the lettering on the menu can be finished in ink.

**7** Work on the border should be undertaken last, to reduce the risk of smudging. Once the design has been mapped out with a fine-nibbed pen, carry out any foil or gilding work, add color and lastly add any missing outlines or minor details with waterproof ink.

##  Place Cards

**1** The place cards should follow a similar sequence of events.

**2** However, when centering names, firstly crease or indicate the fold in the card before finalizing any work in ink.

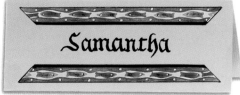

anly pints e bar at the gym we al
orange Because
er, everyone congratulated me on m
weren't being sarcastic. In the car,
ath, Gershwin and I talked of noth
ected the game, talked strategy and
t be a good idea to have mid-we
ll talk, of course, but comfortin
fancy coming to ours for Su

you having?' I asked.
would be something ex
d the rest of the day o
e coming down from
- chicken, veg, roa
m with them your
r?'
l promised to
ner table too
ssing one S
y mum's got a good memo
day and the-staying
r I've had to

**ELIZABETH**

**1952**

brillia
I didn
'Did y
'Nah,'
up high e
He stopped
'Have you th
'A bit, I sup
to think I was g
Gershwin laugh
'Far from it, m
doubt very much
I paused, thinking.
be friends now that
'Zoë seemed to
between the two of
tends to be quite g
I tried not to loo
said cas

# *Project Two*
## Bookmark

### YOU WILL NEED

Artist's watercolors and/or gouache paint

Calligraphy ink

Craft knife and cutting board

Card

Gold leaf or foil

A metal ruler

Paper—sketch and tracing

Paint brushes

Pencils—HB, conté carbon and an eraser

Pen nibs, including a mapping pen and nib

Purified water (for washing pen nibs and brushes)

Glue, gum arabic, or gesso

Waterproof black ink or waterproof French sepia

**Although smaller in scale than some projects, a bookmark can be an ideal format to display your new found skills.**

Bookmarks can be both beautiful and practical and you can theme your design how you like. You could commemorate an event (personal or national,) or perhaps you would prefer to reflect the theme of your current reading material.

Once you have finished you could try laminating your project to protect it from everyday handling.

**1** Using good-quality thin card, of an appropriate size and shape, decide upon the elements of the composition. In this example the balance of the border, crown and the word "Elizabeth" are most important. Work out these relationships in rough first.

**2** On the cutout bookmark (if preferred the bookmark could be cut out later, however the outline needs to be clearly marked,) indicate the constraints of the border before adding any detail.

**3** Calculate the number of letters and spaces for the year and "Elizabeth." Once satisfied, trace onto the bookmark but remember to leave enough room for the crown and rose motifs. Trace the number two before "Elizabeth" to avoid confusion later.

**4** As with the previous projects, the crown and rose design should be worked out on tracing paper first, transferred onto the bookmark and the lines drawn over again in pencil. If possible try to combine this stage with step 3.

**5** Work over the pencil lines with a mapping nib. When dry, rub away any pencil lines.

**6** If you intend to recreate the gilding, you need to prepare the areas and apply the gold leaf or foil.

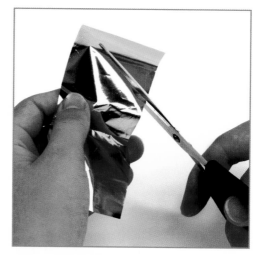

**7** When the gilding is complete, paint the colored sections of the rose, crown, and lettering. Outline the areas of gilding with waterproof ink once the paint has dried.

**8** The last stage is to finish the border. However, paint in the background with watercolors beforehand.

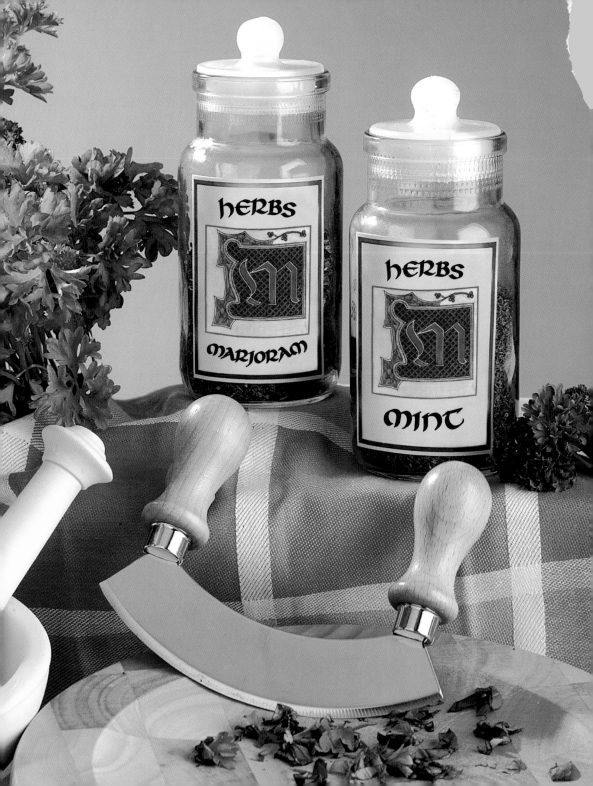

# *Project Three*
## *Labels for Herb Jars*

YOU WILL NEED

Artists watercolors and/or gouache paint

Calligraphy ink

Craft knife and cutting board

Gold leaf or gold foil

A metal ruler

Paper—artist, sketch, and tracing

Paint brushes

Pencils—HB, H, conté carbon, and an eraser

Pen nibs, including a mapping pen and nib

Purified water (for washing pen nibs and brushes)

Glue, gum arabic, or gesso

Waterproof black ink or waterproof French sepia

**When putting your calligraphy skills into practice don't feel limited or restricted by traditions, embrace them and use them to suit your own needs. Why not embellish everyday items such as herb jars?**

By now you should feel familiar with illuminated versals and be aware of their traditional use at the beginning of manuscript verse and text.

As this project shows you can use illuminated versals in different ways. In addition to herb jar labels, you could try making stunning labels for jam or other household items. Laminating or covering in sticky back plastic will help protect your design against spills and knocks.

**1** Select a suitable capital letter for your label and sketch out a design.

**2** When satisfied with the overall shape of the letter and the positioning of the text, make a tracing so that the letter may be transferred upon the paper or parchment. If this tracing line is too faint draw over the line with another pencil.

**3** Work over the penciled line with a mapping pen and erase any pencil marks once the ink has dried. Remember to use only waterproof ink if watercolors are to be used later—since this project requires a lot of paint work this is particularly important.

**4** Lightly sketch, or transfer a tracing of the decoration in position around the capital letter.

**5** Prepare any raised gilding of the capital letter either with gesso or glue, and add either gold leaf or colored foil to the letter.

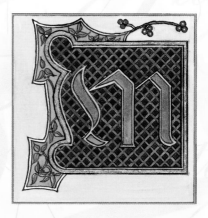

*The Schwabacher type design "M" for this project was originally designed by Johann Bamler of Augsburg in about 1474. The style is a more formal gothic current cursive writing with the capitals being flamboyant and exaggerated. The name was probably derived from a small village in southern Germany. This Schwabacher script is considered to be the ultimate broad pen lettering.*

**6** When the gilding work is complete begin adding color. With this amount of paint work build up the depth of color with a weak wash first, followed by the final shade.

**7** Finally, shade and outline the versal and ink in the the herb name.

# Gordon and Elizabeth Fitzimmons

Request the pleasure of the company of

- - - - - - - - - - - - - - - - - - - - - - - - - - - - - - - - - - - - - -

at the Christening of their Daughter

# CARON LOUISE

at

## St'Begas' Church Bassenthwaite

on Sunday 30 June 2002 at 1·30 pm.

⊶⊷

To be followed by a reception at

## The Nundith Nill Manor Nouse

## Cockermouth

R.S.V.P.

# Project Four

## Christening Invitation

### YOU WILL NEED

Artist's watercolors and/or gouache paint

Calligraphy ink

Craft knife and cutting board

Gold leaf or foil

A metal ruler

Paper—artist, sketch, and tracing

Paint brushes

Pencils—HB, H, conté carbon, and an eraser

Pen nibs, including a mapping pen and nib

Purified water (for washing pen nibs and brushes)

Glue, gum arabic, or gesso

Waterproof black ink or waterproof French sepia

**Whatever the occasion, whether birthday, anniversary or christening, you can add that personal touch by creating handmade invitations.**

A simple, classic design such as the example shown here will allow plenty of room to list the essential details while also commemorating your special day.

Generally, invitations will always look better if the lettering is centered on the paper. Select the capital case first, in this example Uncial letters have been chosen, and then the rest of the letters should be worked around the size and form of the capital case.

**1** Select the paper size; generally no larger than tabloid. Choose an appropriate alphabet: the one shown here is insular majuscule letters with the main title laid out in Roman Uncial.

**2** Scale is of vital importance, so rough drafts produced on tracing paper will indicate the correct pen-nib size. This example used 0.5-, 1- and 1.5- sized nibs. Letter heights must be considered for the text, with larger letters reserved for the most important title etc., followed by an ever-decreasing letter height for less important texts. Interlinear space (space between each line of the text) is another consideration. A balance should always be maintained on the invitation sheet and changing nib widths will make this process easier.

**3** Calculate the number of letters and spaces of the longest line to determine the text width. Pasting up the rough drafts on strips will help when setting out, and also assist in arranging margins and borders before arriving at your final design.

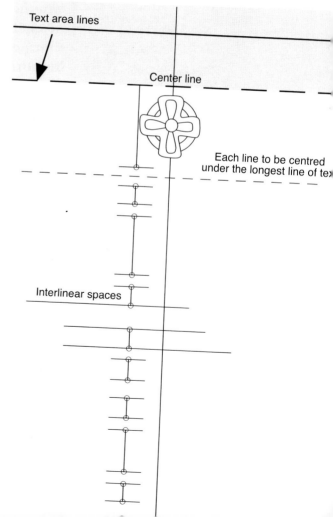

Text area lines

Center line

Each line to be centred under the longest line of text

Interlinear spaces

**4** In this project there is no illuminated versal, instead a simple Celtic cross, centred at the top of the page, provides a splash of color. However, as with versals, you should design your motif separately first.

**5** When satisfied, use a tracing of the image to position it upon the final piece. Use either a conté carbon pencil, or any other soft lead pencil, on the reverse side of the tracing paper to transfer the image. Refine and finalize as necessary.

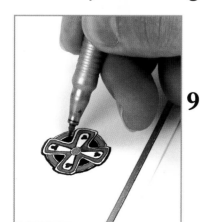

**6** Start working over the lines with a very fine mapping nib; only waterproof ink should be used on areas that come into contact with color. When dry, rub away any pencil lines.

**7** If you are to use gilding, as shown in the example, you need to prepare the areas and apply the gold leaf or foil as discussed earlier.

**8** When the gilding is complete, color work can commence. The first coat of paint should generally be a weaker mix of the final color, followed by a thicker coat of color.

**9** The rest of the manuscript work on the christening invitation can now be completed, followed by the completion of the border with gold foil or leaf and an outline of black waterproof ink.

# *What Next?*

*House signs*

The enthusiast who has tried out everything in this book is a beginner no longer, but a seasoned craftsperson who is probably, by now, fighting off requests from everywhere for hand-drawn lettering of all kinds.

If you do have the time to work on something for yourself, consider these ideas:

• Painted china, favorite recipes, commemorative plates for wedding anniversaries.

• Inscriptions on interior walls, to welcome the visitor or make a difference to a plain room.

*Decorative wall tiles*

• A child's name, painted onto a special chair.

• A family tree with a bride and groom's ancestry, for their wedding present.

• A T-shirt personalized with fabric paints.

*Personalized greetings cards*

- A book of an elderly relative's favorite reminiscences.

- House signs.

*Home decorations*

All these projects will increase your skills but why not try out the intricacies of Celtic scrollwork, and use it to decorate your illuminated letters?

Try using gold leaf, and other alphabets—make up your own alphabets too. Experiment with different papers.

Keep practicing and look out for examples of calligraphy wherever you go. As suggested at the beginning, calligraphy can be applied to cloth, china, and many other surfaces—calligraphy has the power to keep you interested for life!

*Painted china*

61

# *Glossary*

**Use this glossary to clarify the meanings of any terms which may be unfamiliar to you.**

**ARCH**—a curved part of a letter joined to a straight part.

**ARM**—a horizontal part of a letter, such as in E or F, or a diagonal, such as the central part of an N.

**ASCENDER**—the part of a letter which extends above the x-height of a minuscule letter, as in b, l etc.

**BASELINE**—the line on which all letters sit.

**BURNISH**—to polish gold until shiny when used in illumination; rub with a thumbnail or burnishing tool. The process can help repair the surface of paper after correcting a mistake.

**BURNISHER**—the tool used to polish gilding to a fine shine.

**C-HEIGHT**—the height of a capital letter.

**CALLIGRAM**—a design or picture made up entirely of words.

**CAROLINGIAN**—an elegant writing style named after the Frankish ruler, Charlemagne.

**CENTER**—to place lettering so that there are equal spaces at each side of a word or line.

**COPPERPLATE**—a cursive style of writing formed with a thin nib.

**CROSSBAR**—the horizontal line in an A or H, for example.

**CURSIVE**—a flowing version of a calligraphic style of writing in which the letters may be joined together.

**DESCENDER**—
the part of a letter which extends below the baseline, as in p, y, etc.

**DIAPERING**—use of a patterned background in illumination.

**GESSO**—a mixture of plaster and glue used when applying gold leaf. The starting plaster needs to be broken down into a paste with distilled water and can then be applied using a brush.

**GOTHIC**—an angular and intricate writing style.

**GOUACHE PAINT**—translucent paint similar to watercolor. Gum arabic is the best binder for improving this paint's consistency.

**GUM AMMONIAC**—a gum resin that can be used with gold leaf.

**GUM ARABIC**—gum adhesive used in applying loose powdered gold. Mix powdered gold with distilled water and add gum arabic as a binder. The mixture can be applied directly with a brush and burnished once dry. Also used as a paint binder, improving the adhesive quality of paint.

**ILLUMINATED VERSAL**—the finely decorated capital letters found at the beginning of manuscripts.

**ILLUMINATION**—the addition of color to a manuscript.

**INTERLINEAR SPACING**—simply the spaces between lines in a manuscript or project.

**ITALIC**—a sloping, clear writing style developed in Italy.

**KNOTWORK**—a lattice pattern often used in Celtic decoration.

**LADDER**—shown alongside rough letters and designs as a chequered pattern, the "ladder" is used to calculate letter heights. Nib widths may vary but the ladder enables proportions to remain the same.

**MAJUSCULES**—capital letters.

**MINUSCULES**—another word for lower-case letters.

**OX GALL**—as with gum arabic, ox gall improves the consistency and adhesive quality of paints.

**PARCHMENT**—the skin of a sheep which has been prepared as a writing surface; also the term used for a paper which resembles this.

**PLAKA**—durable water-soluble paint.

**RESERVOIR**—the small metal device placed at the back of dip-pen nibs to hold ink and thereby reduce the amount of times the pen has to be dipped into the ink bottle.

**SERIFS**—The small strokes at the ends of letter strokes which originated to act as a brake to a chisel in carved inscriptions.

**SIZE**—a thin mixture of glue, clay, or wax used as a sealer or adhesive on paper. Gesso, gum arabic, and gum ammoniac may all be referred to as "size" in other texts.

**VELLUM**—the skin of a calf prepared as a writing surface.

**VERSALS**—a form of lettering where capitals are drawn in outline with a thin nib.

**X-HEIGHT**—the distance from the baseline to the top of small letters such as a, o, etc.